MIX YOUR OWN

OILS

AN ARTIST'S GUIDE TO
SUCCESSFUL COLOR MIXING

JEREMY GALTON

CHARTWELL
BOOKS, INC.

A QUINTET BOOK

Published by Chartwell Books
A Division of Book Sales, Inc.
PO Box 7100
Edison, New Jersey 08818-7100

This edition produced for sale in the U.S.A., its territories
and dependencies only.

ISBN 0-7858-0264-9

This book was designed and produced by
Quintet Publishing Limited
6 Blundell Street
London N7 9BH

Creative Director: Richard Dewing
Designer: Ian Hunt
Project Editor: Anna Briffa
Photographer: Nick Bailey

Typeset in Great Britain by
Central Southern Typesetters, Eastbourne
Manufactured in Singapore by
Eray Scan Pte Ltd
Printed in Singapore by
Star Standard Industries (Pte) Ltd

CONTENTS

INTRODUCTION

To be confronted by row upon row of oil paint tubes in a local art shop can be confusing enough for the seasoned artist and positively daunting to the beginner. What are they all used for? Why are there so many colors when it is obviously impractical to own the complete range? This book is designed to show you which ones are essential and to demonstrate that, for most purposes, only a handful of tube colors are really necessary. I have prepared whole spreads to show just some of the ways in which colors can be modified or new ones created solely by mixing paints. Primarily with the figurative painter in mind, I have shown how some of the colors found in a series of arranged still lifes can be mixed. Throughout the book I have indicated the approximate proportions of the tube colors that were used to make each mixture. They are given as ratios, using easy-reference symbols. Bear in mind that paints made by different manufacturers have different strengths and you may find that these proportions vary somewhat.

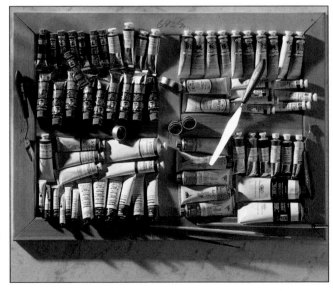

RIGHT
The range
of tube colors
available
in art shops
is vast.

COLOR THEORY AND THE COLOR WHEEL

Red, blue and yellow, known as the primary colors, are hues which cannot be obtained by mixing other colors. Mixing pairs of primary colors produces secondary colors; blue with red makes purple, blue with yellow makes green, and yellow with red makes orange. A color wheel can be constructed of the three primaries, each member of a pair separated by their secondary mixtures. However, there are no such paints as "pure" red, blue or yellow. The pigments used to make the paints are always biased one way or another towards their neighboring secondaries. In this color wheel I have shown how the "greenest"

greens, for example, are best made from those blues and yellows which are biased towards green such as Winsor blue and lemon yellow. Cadmium yellow on the other hand is "warmer," with a bias towards red and is more suitable for making orange. A primary is always opposite a secondary color on the color wheel. These "opposite colors"– for example, red and green – are said to be complementary to each other. If they are mixed, or indeed if three primaries are mixed, a tertiary gray or brown results depending on exactly which paints are chosen and in what proportion.

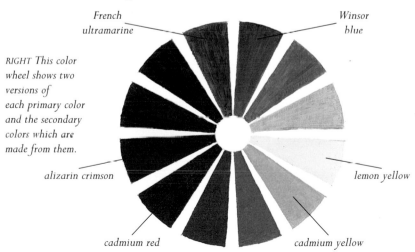

French ultramarine

Winsor blue

RIGHT *This color wheel shows two versions of each primary color and the secondary colors which are made from them.*

alizarin crimson

lemon yellow

cadmium red

cadmium yellow

THE STARTER PALETTE

As you will gather from the following pages a vast range of colors is obtainable from very few tube colors. I usually use ten basic ones including white as follows:

- French ultramarine
- yellow ocher
- raw umber
- Payne's gray
- cadmium yellow
- lemon yellow
- alizarin crimson
- cadmium red
- Winsor violet
- titanium white

Four more which I also find quite useful are Winsor blue, sap green, burnt umber and ivory black. As you read through the book you will see the uses of extra paints that you will probably like to collect as you need them. I have also included a few exotic ones which you will seldom need but which may prove essential for certain subjects.

Before embarking on a painting, all the paints you are likely to use should be spread out along the outer edge of the palette. This is to avoid fumbling with them later when you are trying to concentrate on the painting. Also it means you cannot be discouraged from using any one color simply because it's not there ready for use. The center of the palette is for mixing, and I will be saying more about this on the following pages.

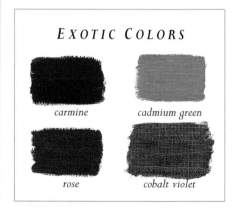

USEFUL COLORS

Winsor blue

sap green

burnt umber

ivory black

EXOTIC COLORS

carmine

cadmium green

rose

cobalt violet

SUGGESTED STARTER PALETTE

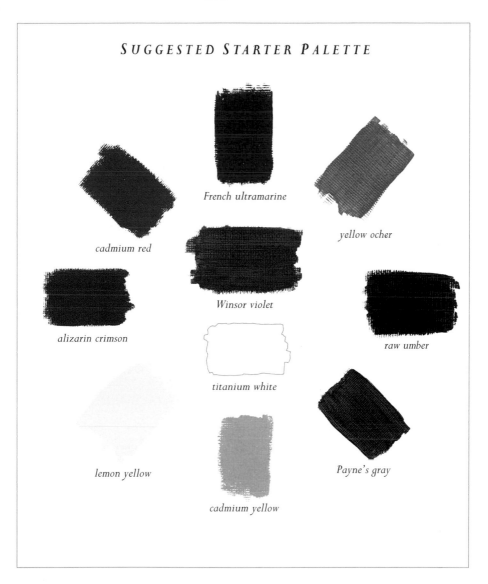

French ultramarine

yellow ocher

cadmium red

Winsor violet

alizarin crimson

raw umber

titanium white

lemon yellow

Payne's gray

cadmium yellow

MATERIALS AND MIXING COLOR

Ideally mixing should be done with a painting knife, its size chosen according to the amount of paint involved. For fast work such as a landscape on location it is more convenient to use brushes for mixing, although they do become worn much more quickly, especially the more expensive sable brushes. Those brushes with synthetic fibers should never be used to mix paints since any rotary action quickly and irreversibly twists the fibers out of shape.

Paint can be used straight out of the tube or it can be thinned with a painting medium. I like to use a mixture of two thirds pure turpentine with one third refined linseed oil. This gives a fairly glossy appearance once the paint is dry. Brushes should be cleaned with oil of turpentine.

To mix a particular color in, say, a still life, it can be a help to isolate it from its surroundings by viewing it through a small hole either cut in a piece of card or made by your thumb and fingers. To ensure your color is accurately mixed, try holding the paint on the brush or painting knife up to the subject and see if the colors coincide. Always thoroughly mix the paint on the palette before applying it to your picture. Before loading a brush up with a new color it must be well cleaned of the previous color.

It is advisable to use as few colors as possible in a mixture to avoid muddying and possibly long-term unwanted chemical reactions between pigments. Sometimes, though, one does not hit on the right mixture until numerous adjustments with traces of other colors are made.

BELOW A selection of painting knives.

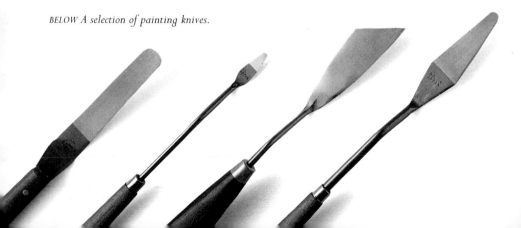

RIGHT Generally you should use a painting knife to mix your colors.

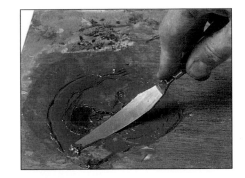

RIGHT Change the size of your painting knife according to the amount of paint you are mixing.

RIGHT Use brushes sparingly when mixing, since they tend to get worn easily.

MIXING BLUE – SKY AND SEA COLORS

Only rarely does an unmixed blue, straight from the tube, meet one's needs. Although the sky, the ocean or a blue lake may appear very blue they are in fact very muted and usually vastly different from any tube color. On these pages I have mixed a selection of "blues" typical of what one may find in natural situations.

I have shown here how very small amounts of yellow ocher can modify a French ultramarine/white mixture. Many such mixtures frequently correspond to the colors seen in the sky. Try also mixing with French ultramarine traces of other colors such as alizarin crimson to obtain sky colors.

The effect of mixing French ultramarine with viridian or raw umber and in each case a trace of white is also shown. Many of these mixtures may be found for example in a "dark blue" ocean, in shadows, among foliage or on the shaded walls of buildings.

** represents a 10:1 French ultramarine/white mixture
* represents a 1:1 French ultramarine/white mixture

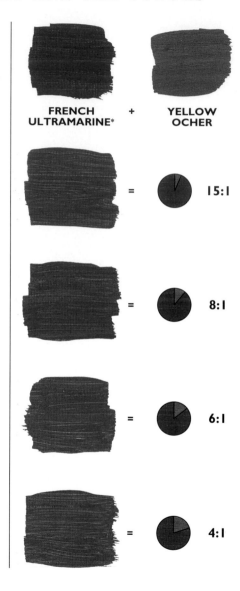

FRENCH ULTRAMARINE* + **YELLOW OCHER**

= 15:1

= 8:1

= 6:1

= 4:1

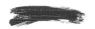

FRENCH ULTRAMARINE	+	**VIRIDIAN**	**FRENCH ULTRAMARINE****	+	**RAW UMBER**

= 3:1 = 20:1

= 2:1 = 16:1

= 1:1 = 14:1

= 1:2 = 10:1

LIGHTENING AND DARKENING BLUE MIXTURES

French ultramarine with traces of cadmium yellow provides us with blues tending towards green, colors I often use for distant landscape.

A blue can be made paler without losing its particular quality simply by adding white. Indeed a small amount of white intensifies the "blueness" of the darker tube colors such as French ultramarine blue, which explains why I often use such mixtures as base colours. Darkening a blue is often achieved most effectively by mixing colors other than black, as shown here with a Winsor blue/cadmium red mixture.

* represents a 10:1 French ultramarine/white mixture

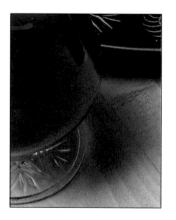

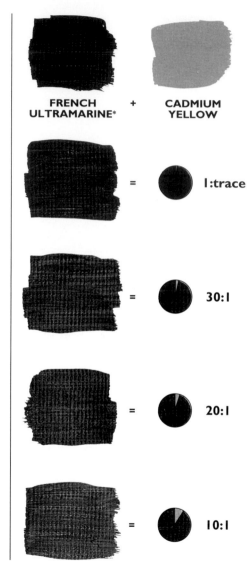

FRENCH ULTRAMARINE* + **CADMIUM YELLOW**

= 1:trace

= 30:1

= 20:1

= 10:1

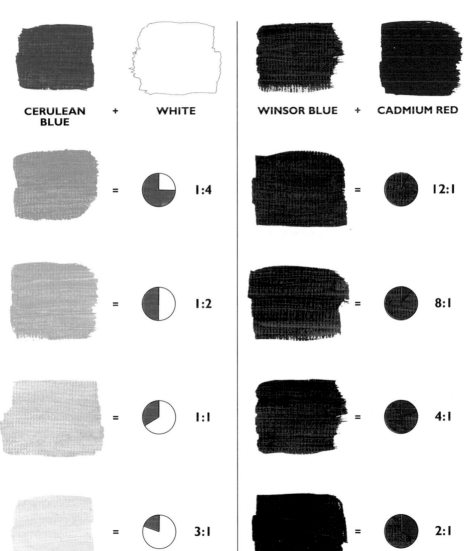

CERULEAN BLUE	+	WHITE		WINSOR BLUE	+	CADMIUM RED

= 1:4

= 12:1

= 1:2

= 8:1

= 1:1

= 4:1

= 3:1

= 2:1

STILL LIFE – BLUE

This rather unlikely collection of blue objects provides an excellent exercise in choosing and mixing blue paints. Interestingly, the pigments used in coloring glass or earthenware are often the same as those used to make paints. For instance the glass jug to the right is identical to Winsor blue

2 cobalt blue
1 French ultramarine
1 ivory black

1 cobalt blue
2 white

pure French ultramarine

1 French ultramarine trace white

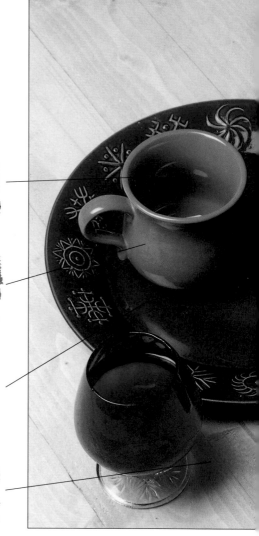

whereas the plate and the brandy glass are pure French ultramarine. Notice how the shapes of these forms stand out as some parts are lit and highlighted and others are plunged into shadow. The background is as important as the subject of a painting. Observe carefully how it varies.

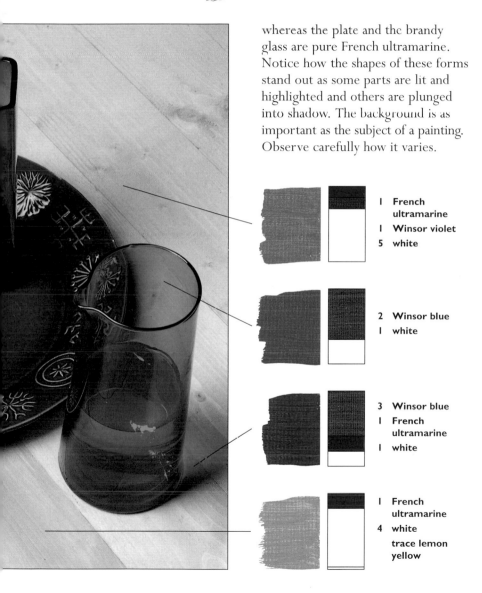

I	**French ultramarine**
I	**Winsor violet**
5	**white**

2	**Winsor blue**
I	**white**

3	**Winsor blue**
I	**French ultramarine**
I	**white**

I	**French ultramarine**
4	**white**
	trace lemon yellow

GALLERY – BLUE

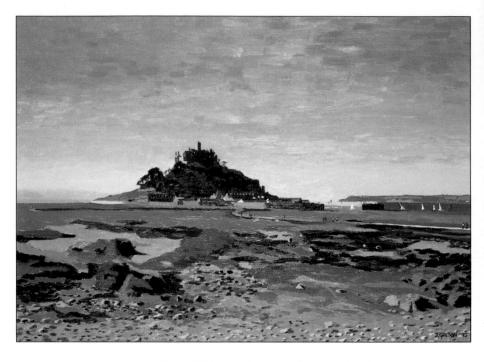

On this brilliant fall day the sky was an almost pure French ultramarine/white mixture, particularly at the top right of the picture. Increasingly towards the horizon I have mixed in alizarin crimson, yellow ocher and raw umber. The water in the rock pools reflects the same colors but toned down further still. The dark blue shaded side of the castle is based on Payne's gray with additions of French ultramarine and white. The distant hills contain a good proportion of Winsor violet.

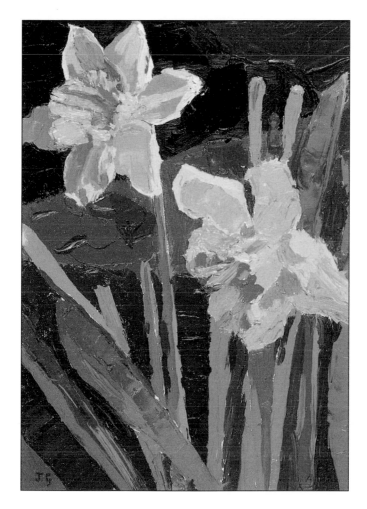

In this small picture the paints were mixed and applied with a painting knife. Notice how little cadmium yellow is used pure, the majority of the yellow being toned down or darkened with raw umber, French ultramarine and Winsor violet.

MIXING YELLOW

These pages show some ways in which the two most commonly used yellows, cadmium and lemon, can be lightened and darkened. Lightening can only be achieved by adding white. Notice just how much has to be added to cadmium yellow to have any effect. When it does, i.e., with large amounts of white, the yellow's brilliant character is lost. Lemon yellow on the other hand is better at keeping its "yellowness" on addition of white, and less white is in fact needed. Both yellows are best darkened with browns or purples. Illustrated here are various mixtures of cadmium yellow with burnt umber, raw umber and Winsor violet, and a mixture of lemon yellow with yellow ocher.

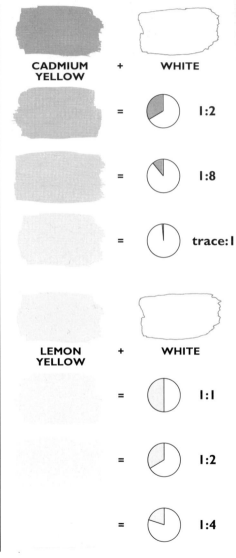

CADMIUM YELLOW + WHITE

= 1:2

= 1:8

= trace:1

LEMON YELLOW + WHITE

= 1:1

= 1:2

= 1:4

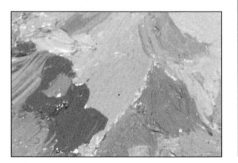

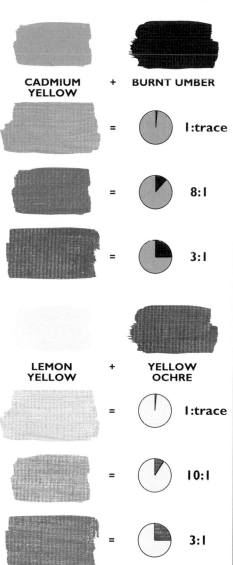

CADMIUM YELLOW + **BURNT UMBER**

= 1:trace

= 8:1

= 3:1

LEMON YELLOW + **YELLOW OCHRE**

= 1:trace

= 10:1

= 3:1

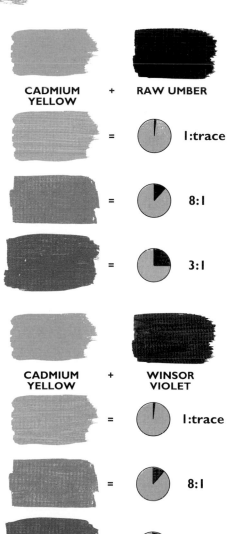

CADMIUM YELLOW + **RAW UMBER**

= 1:trace

= 8:1

= 3:1

CADMIUM YELLOW + **WINSOR VIOLET**

= 1:trace

= 8:1

= 4:1

STILL LIFE – YELLOW

Natural yellow objects are seldom as bright and pure in color as they may seem. Although the most strongly lit areas of a lemon may appear almost pure lemon yellow the majority of its surface may well have to be described in browns or other colors depending on the reflections it receives from its

8 **lemon yellow**
1 **yellow ocher**

6 **cadmium yellow**
2 **burnt umber**
1 **cadmium red**

4 **white**
1 **lemon yellow**
1 **yellow ocher**

4 **cadmium yellow**
2 **cadmium red**
1 **burnt umber**

surroundings. The lemon pot at the top right of the photograph curves round into a dark red-brown shadow, and at its extreme right edge is lit with a bluish reflection from the board behind. Much of the enjoyment in painting a still life is in the discovery of the unexpected.

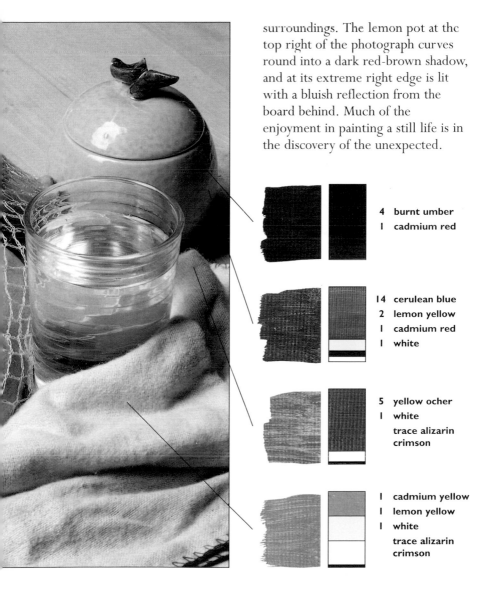

4 burnt umber
1 cadmium red

14 cerulean blue
2 lemon yellow
1 cadmium red
1 white

5 yellow ocher
1 white
trace alizarin crimson

1 cadmium yellow
1 lemon yellow
1 white
trace alizarin crimson

MIXING RED

It is not normally necessary to own more than two or three red tube colors. One orange-biased color such as cadmium red and one purple-biased one such as alizarin crimson are quite enough for most purposes. Darkening and lightening these colors requires some skill if their characteristic hues are to be retained. Simply adding white to cadmium red gives a washed-out pink but with the extra addition of a little cadmium yellow you can obtain a good pale version of cadmium red. Similarly, the addition of black quickly destroys its quality whereas if burnt sienna (a reddish brown) or alizarin crimson is added instead an acceptable darkened cadmium red is formed.

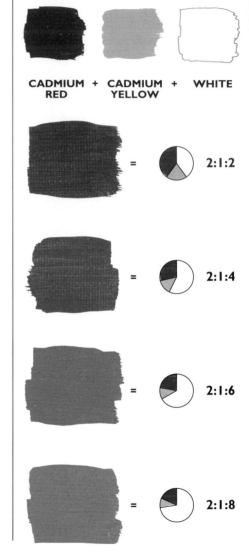

CADMIUM + CADMIUM + WHITE
RED YELLOW

= 2:1:2

= 2:1:4

= 2:1:6

= 2:1:8

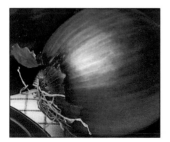

| CADMIUM RED | + | BURNT SIENNA | | CADMIUM RED | + | ALIZARIN CRIMSON |

 = 4:1 = 2:1

 = 2:1 = 1:1

 = 1:2 = 1:2

 = 1:4 = 1:3

MIXING PINK

The addition of varying amounts of white to our starter palette reds (alizarin crimson and cadmium red) will give a number of pinks. These can be modified by traces of other colors producing most of the hues commonly found in, for example, skin, fruit, brickwork or even sunsets. However, when you are painting flowers you will often need colors of greater brilliance. On these pages I have mixed a selection of the brightest reds and violets with, firstly, two parts and then four parts white. It is helpful to be familiar with the characteristic qualities of these colors to avoid wasting time in trial and error. After all, petals drop, buds open and flower heads turn to the light. Speed is essential!

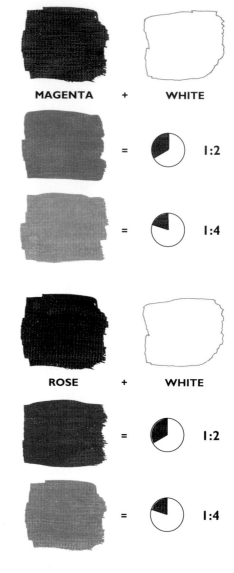

MAGENTA + **WHITE**

= 1:2

= 1:4

ROSE + **WHITE**

= 1:2

= 1:4

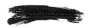

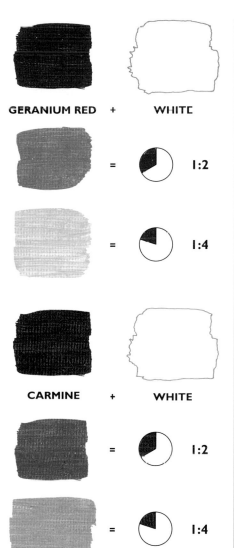

GERANIUM RED + WHITE

= 1:2

= 1:4

COBALT VIOLET + WHITE

= 1:2

= 1:4

CARMINE + WHITE

= 1:2

= 1:4

VENETIAN RED + WHITE

= 1:2

= 1:4

All these objects are similar in color and the reflections each receives is mostly from other surrounding red objects. And yet the variety of hues found here is surprisingly wide. Perhaps the most difficult colors to mix are the very dark tones. For the jug's shadow cast on the red book I

2 alizarin crimson
2 cadmium red
I white

I alizarin crimson
I cadmium red

I alizarin crimson
I carmine
2 white
trace lemon yellow

I alizarin crimson
I carmine

used alizarin crimson darkened with cadmium green, approximately its complementary color. For the accurate portrayal of many painted or glazed objects it is often necessary to use such exotic colors as carmine red, as I have for the saucer in this photograph.

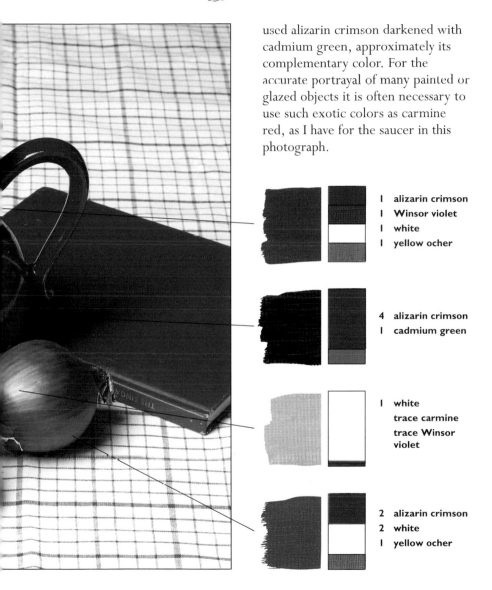

1 **alizarin crimson**
1 **Winsor violet**
1 **white**
1 **yellow ocher**

4 **alizarin crimson**
1 **cadmium green**

1 **white**
 trace carmine
 trace Winsor violet

2 **alizarin crimson**
2 **white**
1 **yellow ocher**

GALLERY – RED

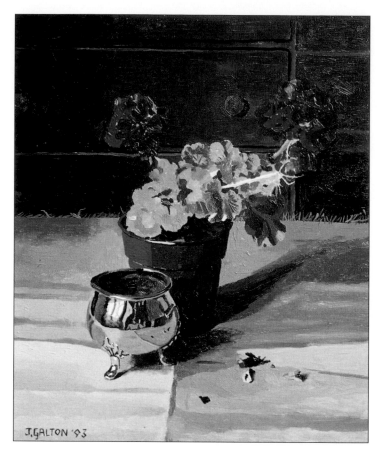

J.GALTON '93

*Tackling brightly-colored flowers often necessitates the use of tube
colors which you would not normally have on your palette. Although
pure cadmium red corresponds well to the color of poppies, for
example, here I had to use cadmium scarlet and the brilliant but
fugitive geranium lake in addition. The latter color will fade,
particularly if mixed with other colors. The flower pot is painted in
mixtures based on burnt sienna.*

GALLERY – ORANGE

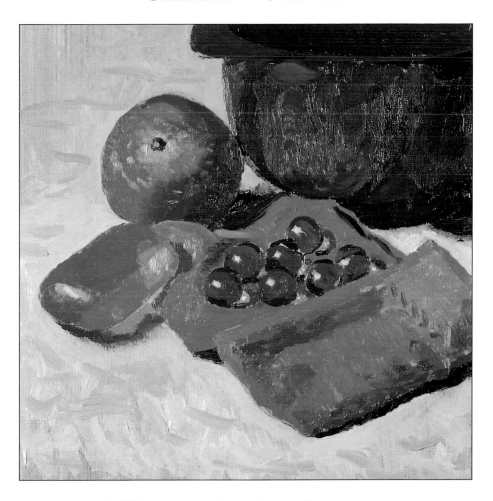

A still life exercise such as this provides an excellent opportunity to explore the relationships between objects of a similar color. With so much orange in front of me I was forced to look for all the small variations in hue and tone in order to give form and depth to my subject.

MIXING ORANGE

The best orange colors are made by mixing cadmium red with cadmium yellow because both tend towards orange. They are the tube primaries adjacent to orange in the color wheel. Such mixtures are identical to the orange tube colors and so it is not necessary to buy them. Alizarin crimson and lemon yellow do not produce a satisfactory orange so this combination is omitted here. However, as long as one component of the red-yellow pairs is a cadmium color a mixture we can call "orange" will be produced.

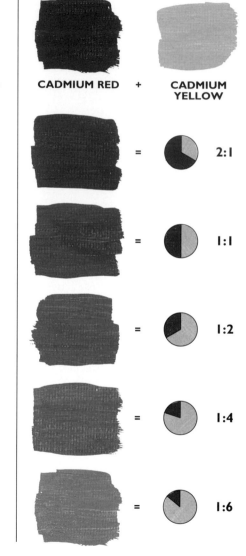

CADMIUM RED + **CADMIUM YELLOW**

= 2:1

= 1:1

= 1:2

= 1:4

= 1:6

| ALIZARIN CRIMSON | I | CADMIUM YELLOW | | CADMIUM RED | + | LEMON YELLOW |

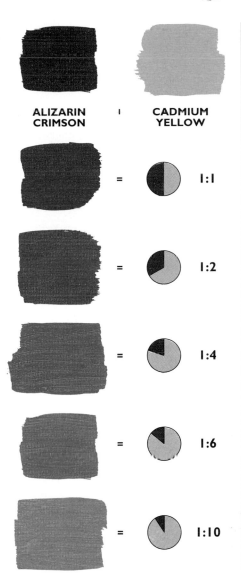

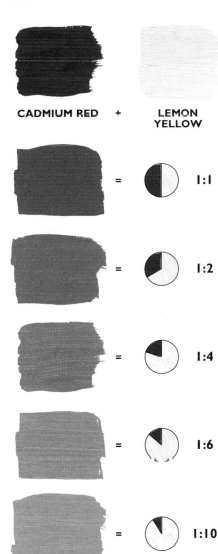

STILL LIFE – ORANGE

Most orange colors can be mixed simply with various reds and yellows in varying proportions, perhaps toned down with green or the complementary color to orange, blue. Look carefully at an orange and see how its shaded side appears basically brown. The color of this

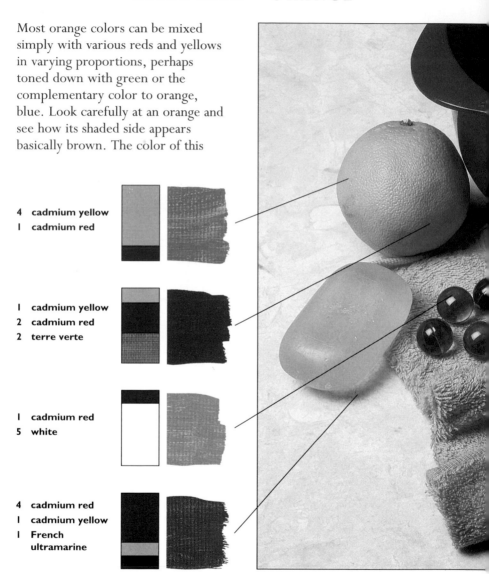

4 **cadmium yellow**
I **cadmium red**

I **cadmium yellow**
2 **cadmium red**
2 **terre verte**

I **cadmium red**
5 **white**

4 **cadmium red**
I **cadmium yellow**
I **French ultramarine**

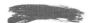

shadow will be modified by reflections received by nearby objects, sometimes creating the most unexpected colors. The colors of reflected highlights on shiny orange objects will depend mostly on the illumination and to a small extent on the exact color beneath the reflection.

I	cadmium red
I	alizarin crimson
I	Winsor violet

3	cadmium red
3	French ultramarine
I	white

4	cadmium red
I	cadmium yellow

2	alizarin crimson
I	lemon yellow
I	cadmium yellow
2	white

MIXING GREEN

From the many blues, blacks and yellows available, a staggering range of greens can be mixed. In general the greener the blue such as Winsor blue or cerulean blue for example, the greater their "greening" effect when mixed with yellow. Often only a trace of blue can change a yellow to a respectable green, while a trace of yellow has little effect on a blue. Notice the rich greens that can be made from Payne's gray, which actually has a large element of blue in it.

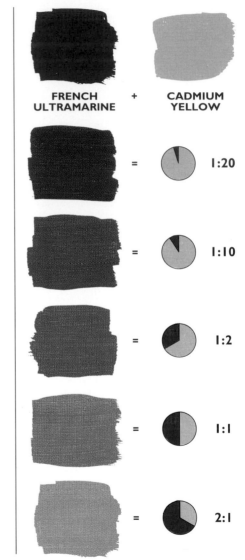

FRENCH ULTRAMARINE + **CADMIUM YELLOW**

= 1:20

= 1:10

= 1:2

= 1:1

= 2:1

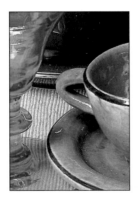

PAYNE'S GRAY +	**LEMON YELLOW**	**CERULEAN BLUE** +	**LEMON YELLOW**

	=		1:20		=	1:20
	=		1:10		=	1:10
	=		1:4		=	1:1
	=		1:2		= 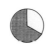	2:1
	=		1:1		=	10:1

MIXING DARK GREEN

Winsor blue is a powerful greenish blue and mixes with yellows to form brilliant greens that are unlikely to be found in nature. However, with yellow ocher (a dull yellow/pale brown) small quantities of Winsor blue can form some beautiful cool greens, very useful for foliage. Ivory black has only a hint of blue in it and when mixed with yellow forms a series of dull, although warm, colors that can just about be classed as "green."

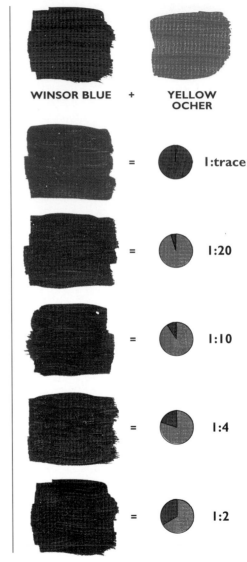

WINSOR BLUE + **YELLOW OCHER**

= 1:trace

= 1:20

= 1:10

= 1:4

= 1:2

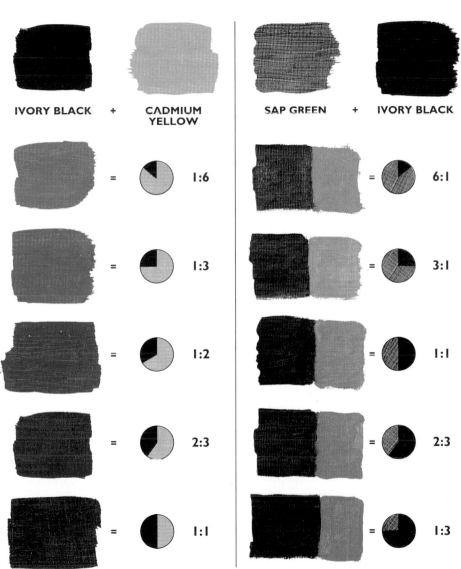

IVORY BLACK	+	CADMIUM YELLOW		SAP GREEN	+	IVORY BLACK
	=	1:6			=	6:1
	=	1:3			=	3:1
	=	1:2			=	1:1
	=	2:3			=	2:3
	=	1:1			=	1:3

USEFUL GREEN MIXTURES

Often when painting shaded foliage in a landscape or still life you will need the darkest greens. A simple way to achieve such tones is to add black to an already dark green – I usually use sap green. Incidentally, when white is added to these mixtures a whole new range of lovely colors presents itself as shown on the previous page.

A strong, bright color such as cadmium green would seldom be used "neat" in a painting but once it

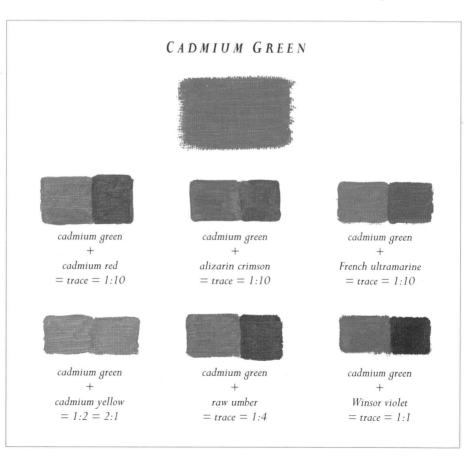

CADMIUM GREEN

cadmium green
+
cadmium red
= trace = 1:10

cadmium green
+
alizarin crimson
= trace = 1:10

cadmium green
+
French ultramarine
= trace = 1:10

cadmium green
+
cadmium yellow
= 1:2 = 2:1

cadmium green
+
raw umber
= trace = 1:4

cadmium green
+
Winsor violet
= trace = 1:1

has been modified or subdued by the addition of other colors, a useful range of greens are produced. In contrast terre verte is a rather transparent paint of low tinting strength. It can either be used to increase the bulk of a paint mix without changing its color much or it can be a useful foundation to which mere traces of other colors can be added in order to alter its appearance quite significantly.

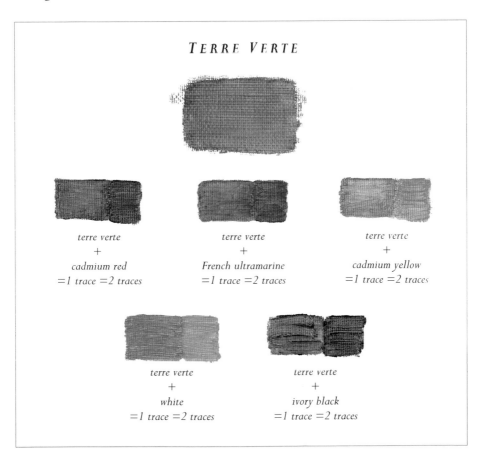

TERRE VERTE

terre verte
+
cadmium red
=1 trace =2 traces

terre verte
+
French ultramarine
=1 trace =2 traces

terre verte
+
cadmium yellow
=1 trace =2 traces

terre verte
+
white
=1 trace =2 traces

terre verte
+
ivory black
=1 trace =2 traces

STILL LIFE – GREEN

I rarely use green tube colors except to modify other colors or to produce the darker hues with sap green. The shaded area of the cup in this photograph is an example of the latter. Notice how I have used Winsor blue to produce the cooler, bluer greens and French ultramarine

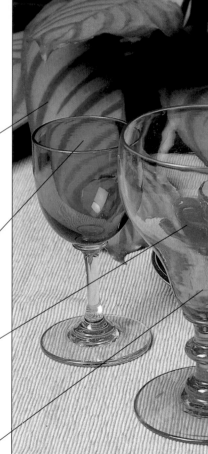

3 Winsor blue
1 cadmium yellow
 trace white

6 Winsor blue
1 cadmium yellow
2 white

2 Winsor blue
2 Payne's gray
1 lemon yellow
1 white
 trace cadmium
 yellow
 trace French
 ultramarine

3 Winsor blue
4 yellow ocher
4 white
1 cadmium yellow

to produce the warmer, yellower greens. Although as few colors as possible should be mixed, sometimes it is difficult to discover the right mixture straight away and you will find that numerous adjustments, using traces of other colors will have to be made.

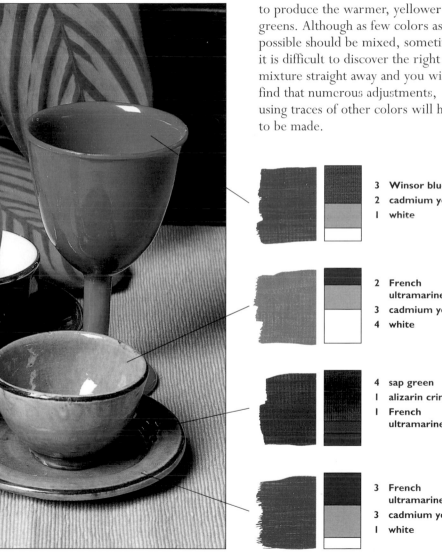

3 **Winsor blue**
2 **cadmium yellow**
1 **white**

2 **French ultramarine**
3 **cadmium yellow**
4 **white**

4 **sap green**
1 **alizarin crimson**
1 **French ultramarine**

3 **French ultramarine**
3 **cadmium yellow**
1 **white**

GALLERY – GREEN

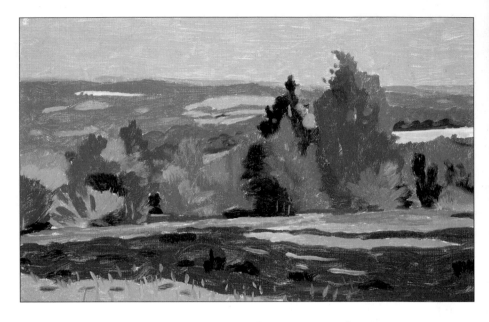

This oil sketch was painted very quickly, the main row of trees being blocked in simply with just a few greens. Payne's gray or French ultramarine with cadmium yellow in varying proportions were mostly used. The darkest shadows are mixtures based on sap green with ivory black or Payne's gray.

GALLERY – PURPLE

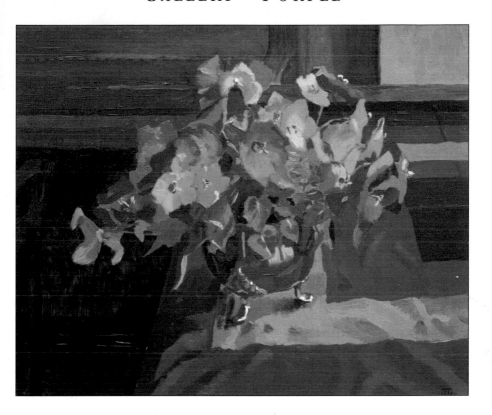

A mixture of Winsor violet and white corresponded well to the local color of these petals. For the highlighted areas and the petals in shadow I found it was necessary to add alizarin crimson and/or French ultramarine in varying proportions. It is important to look carefully at the gradations in color and tone so that the structure of the petals can be defined.

MIXING PURPLE

Purples (and I include under this title the violets and mauves) are secondary colors made by mixing blues and reds. The more the chosen blue and red tend towards purple (their common neighbor in the color wheel) the more intense the resulting purple. French ultramarine, alizarin crimson and rose red are examples. In contrast, Winsor blue which is green-biased, produces only weak purples. French ultramarine when mixed with cadmium red, which tends towards orange rather than purple, results in colors we would normally describe as browns and grays. Such mixtures are illustrated in the sections on browns and grays.

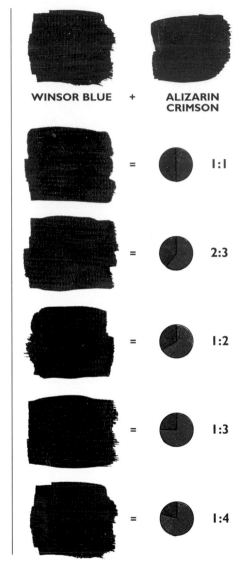

WINSOR BLUE + **ALIZARIN CRIMSON**

= 1:1

= 2:3

= 1:2

= 1:3

= 1:4

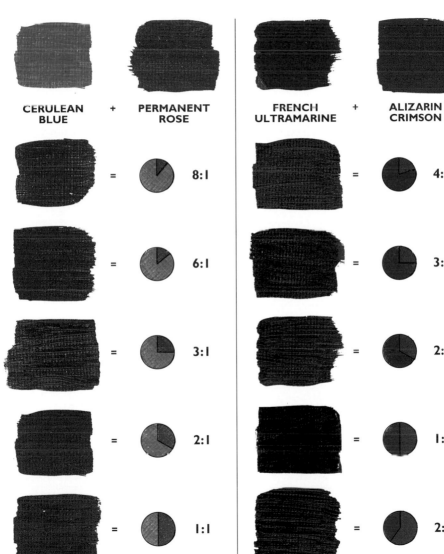

CERULEAN BLUE	+	**PERMANENT ROSE**		**FRENCH ULTRAMARINE**	+	**ALIZARIN CRIMSON**

= 8:1

= 4:1

= 6:1

= 3:1

= 3:1

= 2:1

= 2:1

= 1:1

= 1:1

= 2:3

STILL LIFE – PURPLE

Generally you will find that most purples can be mixed from the primary reds and blues. However, I recommend Winsor violet as part of your basic palette because it corresponds to colors found in many natural situations. A blue sky reflected in wet sand and the shaded

1 magenta
1 white

1 Winsor violet
2 white

2 carmine red
1 Winsor violet
 trace white

1 carmine red
4 white
 trace Winsor
 violet

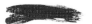

side of a white building are examples. For the most brilliant of purples – those found in flowers or artificially colored objects such as in this still life photograph – you will probably have to resort to using magenta, carmine or rose as I have here.

4 **carmine red**
4 **Winsor violet**
I **yellow ocher**
 trace white

3 **carmine red**
2 **magenta**
I **white**

 pure Winsor violet

2 **Winsor violet**
2 **alizarin crimson**
 trace white

MIXING BROWN USING COMPLEMENTARY COLORS

A wonderful range of rich browns can be obtained by mixing pairs of complementary colors together. Such a complementary pair will always consist of one primary and one secondary color. Brown is essentially a dark yellow. An excellent way to darken, say, cadmium yellow is to add its complementary color, Winsor violet. As long as the colors to be mixed are warm, with a hint of yellow in them, then a brown rather than a gray results. For example, cadmium red and cadmium green are both warm colors. Notice how much cooler the browns are when cadmium red is mixed with viridian instead.

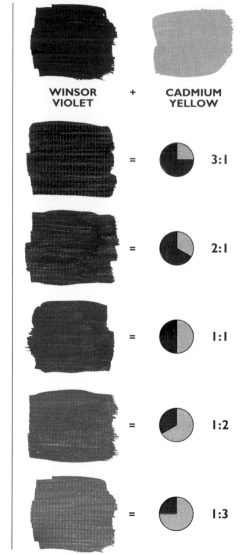

WINSOR VIOLET + **CADMIUM YELLOW**

= 3:1

= 2:1

= 1:1

= 1:2

= 1:3

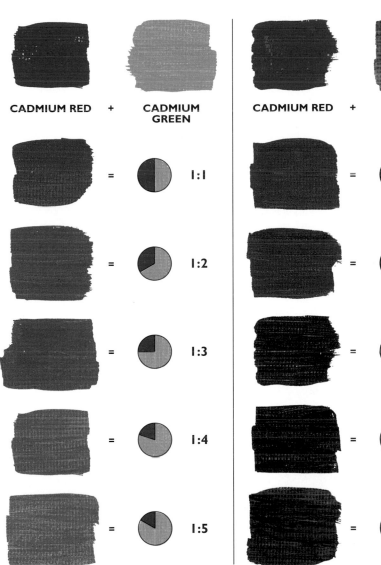

CADMIUM RED + CADMIUM GREEN CADMIUM RED + VIRIDIAN

= 1:1 = 1:1

= 1:2 = 1:2

= 1:3 = 1:4

= 1:4 = 1:6

= 1:5 = 1:9

MIXING BROWN USING PRIMARY COLORS

Mixtures of some pairs of primary colors give acceptable browns or grays. This occurs when they do not form good secondary colors. For instance, one may expect French ultramarine and cadmium red to form purple, but in reality the resulting muddy colors can provide useful browns. With higher blue ratios the browns tend towards gray as can be seen in the section on grays.

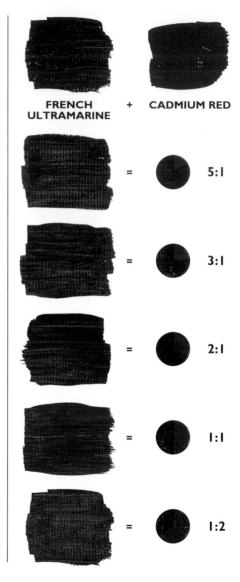

FRENCH ULTRAMARINE	+	CADMIUM RED
=		5:1
=		3:1
=		2:1
=		1:1
=		1:2

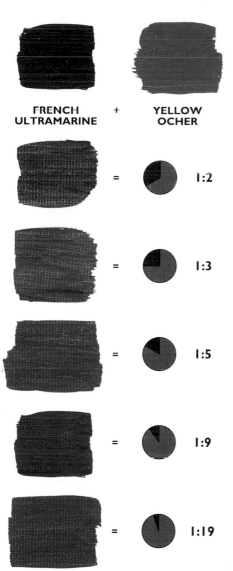

FRENCH ULTRAMARINE	+	**YELLOW OCHER**
=		1:2
=		1:3
=		1:5
=		1:9
=		1:19

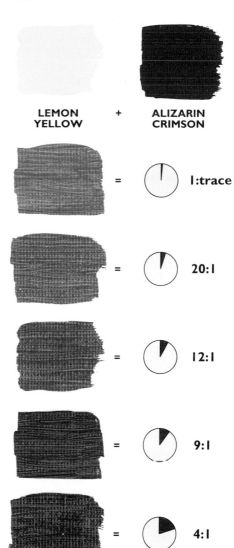

LEMON YELLOW	+	**ALIZARIN CRIMSON**
=		1:trace
=		20:1
=		12:1
=		9:1
=		4:1

MIXING BROWN USING THREE PRIMARY COLORS

Mixing all three primaries is equivalent to mixing one primary with its complementary secondary. Again, if the primaries chosen are warm then brown results, otherwise the mixtures will be gray (see next section). Notice the high tinting strength of alizarin crimson and how little is needed to make the mixture predominantly red.

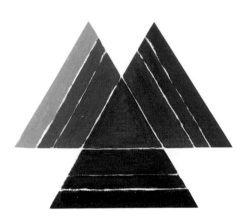

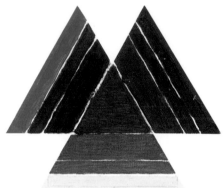

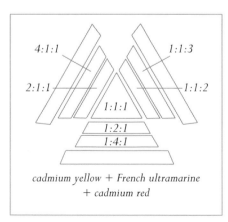

4:1:1 1:1:3

2:1:1 1:1:2

1:1:1

1:2:1

1:4:1

cadmium yellow + French ultramarine
+ cadmium red

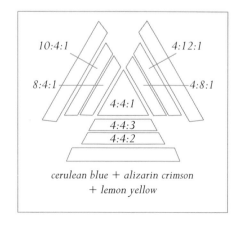

10:4:1 4:12:1

8:4:1 4:8:1

4:4:1

4:4:3

4:4:2

cerulean blue + alizarin crimson
+ lemon yellow

BROWN WITH WHITE

French ultramarine, cadmium yellow and cadmium red mix to form a series of rich, warm, but rather dark browns. The triangle below right shows these colors each mixed with a little white. In contrast compare this to the triangle of gray with white shown on page 64.

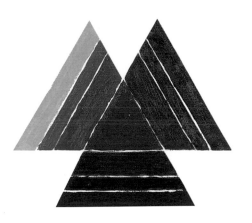

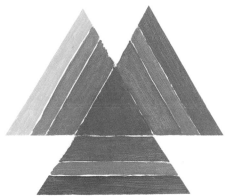

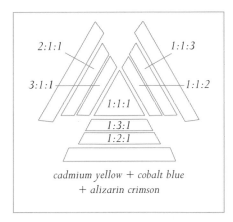

cadmium yellow + cobalt blue
+ alizarin crimson

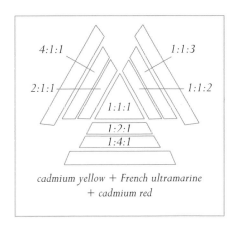

cadmium yellow + French ultramarine
+ cadmium red

STILL LIFE – BROWN

The browns in this still life are surprisingly colorful. One of the excitements of painting is in the discovery of colors that you would not normally have noticed. I have obtained most of the browns for this picture by mixing primary colors. Of course, instead, I could have arrived

3 **cadmium yellow**
1 **alizarin crimson**
1 **cobalt blue**
3 **white**
trace cadmium red

1 **yellow ocher**
2 **white**

4 **cerulean blue**
3 **alizarin crimson**
4 **cadmium yellow**

2 **burnt umber**
1 **cadmium red**

at these same hues by modifying ready-made browns. The danger here is that a monotonous sameness can pervade the colors leading to a dull painting. However, for the very darkest browns it is often advisable to begin with a dark earth color such as burnt umber.

4 **burnt umber**
I **French ultramarine**
I **ivory black**

2 **alizarin crimson**
I **cadmium yellow**
I **cobalt blue**
2 **white**

I **white**
trace alizarin crimson
trace Winsor violet

2 **cadmium yellow**
I **cadmium red**
I **cobalt blue**
2 **white**

GALLERY – BROWN

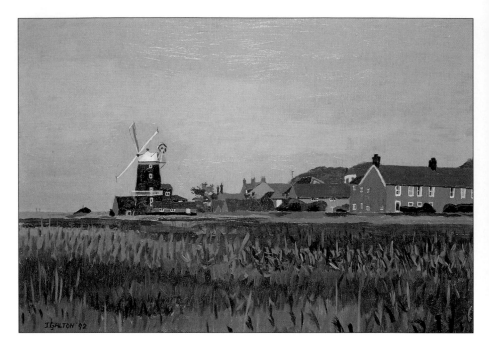

The base of the mill is pure burnt umber as are the darkest of the
flowering reed heads. The broad, brown areas of the reed bed are
painted in a thinned raw umber/yellow ocher mixture in the manner
of the watercolorist's wash. Some individual reeds are painted over
this. The warm browns of the roof tops are mixtures of cadmium red,
French ultramarine and cadmium yellow modified with minute
additions of other colors.

GALLERY – GRAY

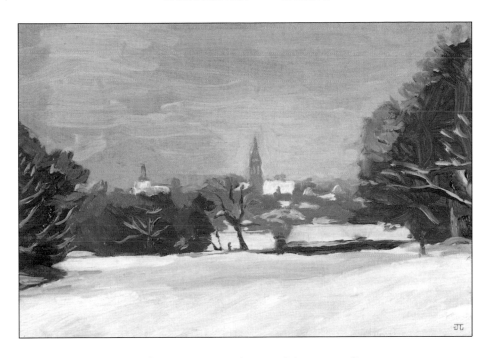

The grays of the sky, the distant houses and the snow are all mixtures of French ultramarine with various reds, yellows and violet. Note that I used no black or tube gray in this painting. As in many of my paintings I mixed each color until it exactly matched the color of the subject. This is checked by holding up the loaded brush so that the color of the paint can be compared side by side with the color of the subject.

MIXING GRAY

Gray is a very vague term describing an infinite range of highly muted and impure colors. Even the most neutral of grays obtained by mixing white with lamp black will take on a colored appearance in juxtaposition with other colors. All the grays illustrated here appear quite colored, but in isolation or in the right context can appear just "gray." They tend to result when a cool pair of complementary colors is mixed or when three cool primaries are mixed. An apparent exception is French ultramarine with cadmium red – the latter has a strong hint of orange in it, the complementary color of blue. All the grays on this page are shown both as single color mixtures as well as with some added white.

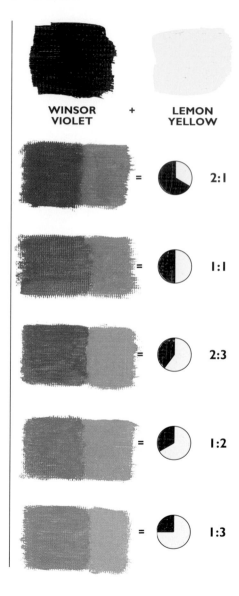

WINSOR VIOLET + **LEMON YELLOW**

= 2:1

= 1:1

= 2:3

= 1:2

= 1:3

FRENCH ULTRAMARINE	+	**CADMIUM RED**	**VIRIDIAN**	+	**ALIZARIN CRIMSON**

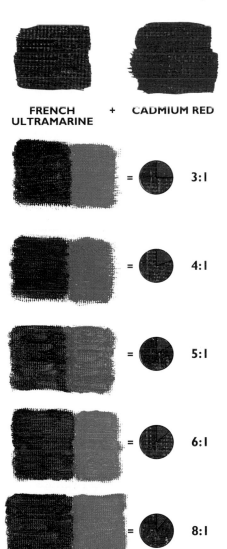

= 3:1

= 4:1

= 5:1

= 6:1

= 8:1

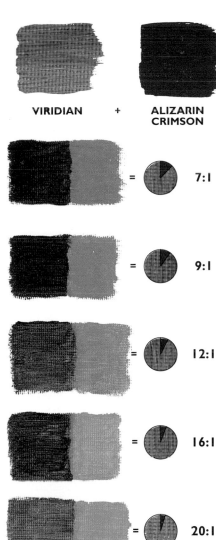

= 7:1

= 9:1

= 12:1

= 16:1

= 20:1

MIXING GRAY USING THREE PRIMARY COLORS

The illustrations on this spread show color mixtures that are all trios of primary colors. Notic e that the mixtures of cerulean blue, lemon yellow and alizarin crimson also appear in the section on mixing brown on page 52. But note that, in this instance, there is a much higher ratio of cerulean blue than there was in the brown mixtures. This is necessary in order to produce such a range of lovely grays. Here again the

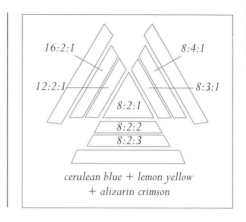

16:2:1 8:4:1

12:2:1 8:3:1

8:2:1

8:2:2

8:2:3

cerulean blue + lemon yellow
+ alizarin crimson

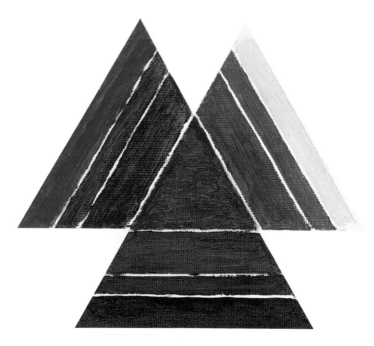

tinting strength of alizarin crimson is most apparent. Winsor blue, cadmium red and lemon yellow are all fairly equal in their tinting strengths which, as you can see, produces a mid-gray in the central triangle. The colors that are produced as a result of these mixtures are all very dark. They can, however, be used as a basis for producing many shades of gray with the addition of white. (See page 64).

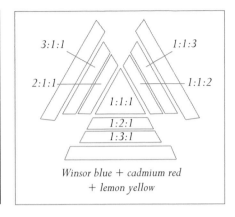

Winsor blue + cadmium red
+ lemon yellow

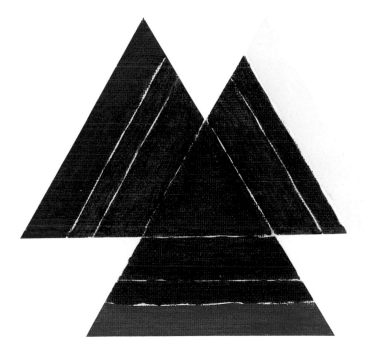

STILL LIFE - GRAY

Unpolished or mat-finished metal such as the stainless steel cup in this photograph often appears as an assortment of grays owing to light-scattering at its surface. In contrast the appearance of the glass is made up of the distorted shapes and gray colors of the pebbles that we see

7 viridian
1 alizarin crimson
2 white

2 French ultramarine
1 alizarin crimson
2 lemon yellow
trace white

3 French ultramarine
1 alizarin crimson
trace lemon yellow

3 viridian
1 alizarin crimson
6 white

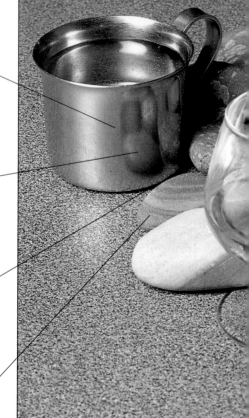

through it. Notice how I have mixed all of the grays using only primary or secondary colors (sometimes with white). It is best to avoid the temptation to use black since purely neutral grays rarely occur in everyday life and your painting may suffer as a consequence.

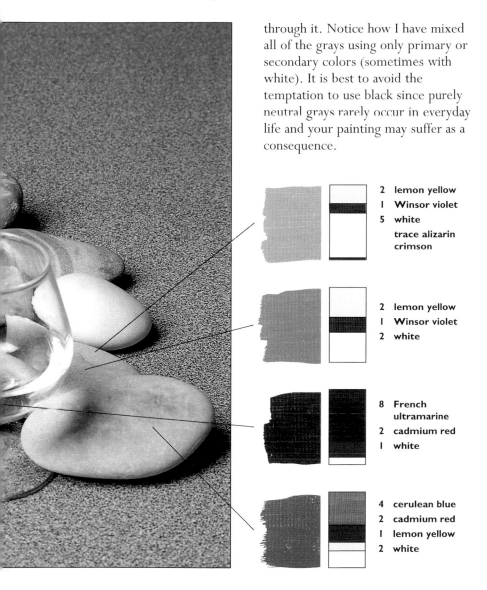

2 lemon yellow
1 **Winsor violet**
5 white
trace alizarin crimson

2 lemon yellow
1 **Winsor violet**
2 white

8 French ultramarine
2 cadmium red
1 white

4 cerulean blue
2 cadmium red
1 lemon yellow
2 white

GRAY WITH WHITE

This triangle is exactly the same as the one on page 61 except that a little white has been added to each mixture. Winsor blue, even in mixtures, has the property of staining the previously white ground on which it is painted. This now blue ground is clearly visible beneath the rest of the paint in this triangle. Other colors containing organic dyes such as alizarin crimson also have this property.

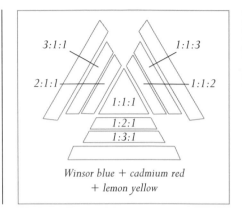

3:1:1 1:1:3
2:1:1 1:1:2
1:1:1
1:2:1
1:3:1

Winsor blue + cadmium red + lemon yellow

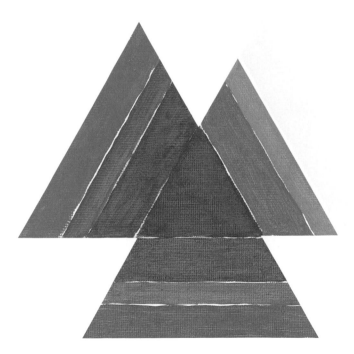